善因

因緣際會、某種程度的同病相憐，和威皓媽媽牽起一線情緣。

人生路上總有許多的無可奈何，但在無奈中也許潛藏著激發我們能耐的機會。人生中，老天爺會丟出甚麼樣的考題都是我們無法預期的，很感激朋友經常讚美我和威皓媽媽堅強，但有時候，當你別無選擇，堅強只能是我們唯一的路。縱使前面一片黑暗，只要走著走著，不期然地，不同的光景自會出現。

生命的困境和挫折中，總是存在著祝福與希望。因著兒子的生病，在走投無路之下來到威皓媽媽的店裡，某日午後，媽媽和我分享著威皓的詩作以及畫作，讓我訝異的是，一個孩子童真的作品裡面竟然有著智慧的老靈魂，一時心裡的悸動促成了這本書的誕生。

吳芸嫻 2018.12.19

Good Will

Through a mutual friend, I got to meet Ms. Huang, Wei-Hao's mother, who shared the same predicament as I.

So many things happen in our life not as we have wished. However, they may tap our potential. In life, the challenges are given unexpectedly. I am grateful to hear people saying that we are tough. Sometimes we have no choice but to be tough. Even if we are going through the darkness, we should not stop going forward. If you keep going, eventually the light will come.

We should hold on hopes and blessings despite the hardships and frustrations in life. Because of my son's sickness, I searched everywhere for help and consultations. Finally, I came to Ms. Huang's place. Huang shared Wei-Hao's poems and painting works with me. I was surprised at the old soul with wisdom hidden behind a child's naïve works. The excitement at that moment led to the coming out of this book.

Yun-Hsien Wu

December 19, 2018

　　從小活潑好動的我，在國小六年級畢業時，上天賜了一個很大的畢業禮物給我，那就是畢業後到醫院檢查，腦袋長了一顆瘤。

　　從此我的人生由彩色變黑白，手術、電療、化療後，我從天堂掉到地獄，生病後的我平衡感不好要坐輪椅，手無法用力握住任何東西，聞到任何食物都想吐，每天像著魔一樣狂灌水、嘔吐、尿尿，腦袋空空無法思考任何事情。

　　休養一年後開始上國中，才發現我不會數學忘了國字！媽媽看我什麼都忘了，於是就帶著我去上我最熟悉的美術課，結果畫圖技巧全忘光了，我上了一堂課就害怕得不敢去上課了。

　　國中課程讓我很害怕，因為我什麼都不會了，每天只會緊張的一直喝水一直吐，經過一年半後，媽媽終於找到一所適合我的學校融合班，情緒才慢慢穩定下來。

　　媽媽為了訓練我的平衡感，陪著我去上爵士鼓課程，國中畢業時，又請了一位老師陪我練習畫畫，雖然只有暑假兩個月的時間，但我漸漸地敢面對畫圖紙了。

　　高中畢業後，在家成立工作室，剛開始用色鉛筆練習，雖然手還是無法將線條畫得很平穩，但慢慢地進步了，漸進地改用水彩筆畫，現在已經訓練到高難度的毛筆了。

　　回想生病迄今，已經有十年了，這十年讓我從零開始學習，感覺能活著真好，在這有限的生命裡，想做些有意義的事情，所以寫了這本書，透過這本書傳達生命的美好！

　　只要活著就有希望，難關難過，關關過！

　　感謝媽媽在生病中照顧我，一路陪著我從零開始學習，是我的良師益友，謝謝爸爸、哥哥、姐姐犧牲許多時間和精力陪我，感恩這一路上幫助我的一切貴人，感恩上天給我最大的考驗。

<div align="right">曾威皓 2019.6.18</div>

I was very lively and active as a little boy, and just at the time I was graduated from elementary school, God gave me a very big graduation gift: I was diagnosed with a tumor in my brain.

Suddenly, my life turned over completely. After going through surgery, electrotherapy and chemotherapy, I felt as if falling from heaven to hell. During the sickness, I did not have a good sense of balance; therefore, I needed to sit on a wheelchair, and my hands could not hold anything firmly. All smells of food made me sick and caused me to vomit, and every day I was madly drinking water, vomiting, going to the toilet like crazy, and I could not think as all mentioned above had emptied my mind.

After one year's treatment, I started junior high school, but I found out I didn't follow the mathematics at all, and I forgot all the Chinese characters! My mother saw me forget everything, so she took me to an art class, because I was supposed to be most familiar with art, but again, I forgot all the painting and drawing skills, and thus I dropped out of the class due to my fears and panic.

I was so frightened by the junior high school lessons, because I could not follow any of them, and I could only drink water and vomit all day long because of anxiety. After one and a half years, my mother finally found in a school a class that tolerated all specialties and thus was suitable for me. After that, my nervousness was getting more stable gradually.

In order to train my sense of balance, my mother accompanied me to a jazz drumming course. When I graduated from junior high school, she also found me a teacher to train my painting skills. Although it was only two months' training in the summer vacation, I finally had the courage to draw.

After graduation from senior high school, I established a studio at home. In the beginning, I used colored pencils to practice. Although I still could not draw a very straight and smooth line, everything was improving slowly. After training myself for some time , I have now moved from the watercolor pens to the advanced writing brushes while painting.

It has been ten years since the tumor was found, and I was given a chance to learn everything from zero again, from the very beginning. I felt it wonderful to be alive, as time is limited for me. I wanted to do meaningful things, and to express the beautiful life of my own is the basic concept in this book,

As long as we are alive, there is hope, and no matter how many obstacles there will be, they can be overcome one by one.

During my illness, I was truly grateful to my mother for taking care of me, for her always standing by my side to help me learn everything. Mother, you are my teacher and my best friend. Thank you, Daddy, my brother and my sister, as you've all sacrificed a lot of time to be with me and give me tremendous courage. I am much obliged to all the people who have helped me in any way. Without you, I could not be so strong. Finally, I want to thank God for giving me such a big test to allow me to explore the biggest potential and possibilities I could ever imagine and for sure I have tided over this challenge and will keep fighting on.

<div align="right">
Wei-Hao Tseng

June 18, 2019
</div>

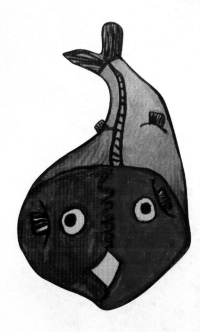

目錄

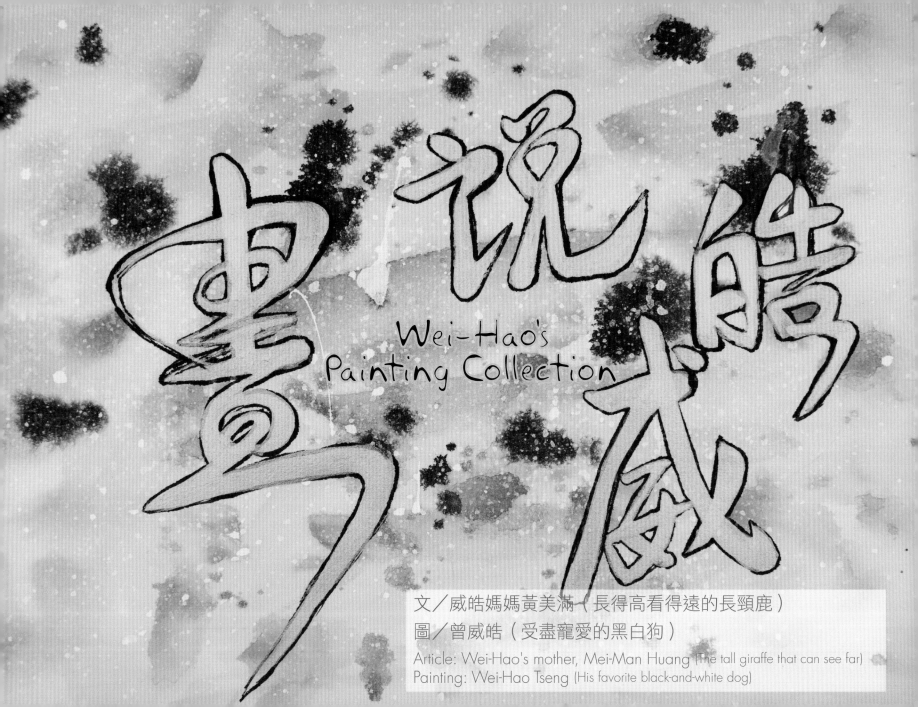

畫說威時

Wei-Hao's
Painting Collection

文／威皓媽媽黃美滿（長得高看得遠的長頸鹿）
圖／曾威皓（受盡寵愛的黑白狗）
Article: Wei-Hao's mother, Mei-Man Huang (The tall giraffe that can see far)
Painting: Wei-Hao Tseng (His favorite black-and-white dog)

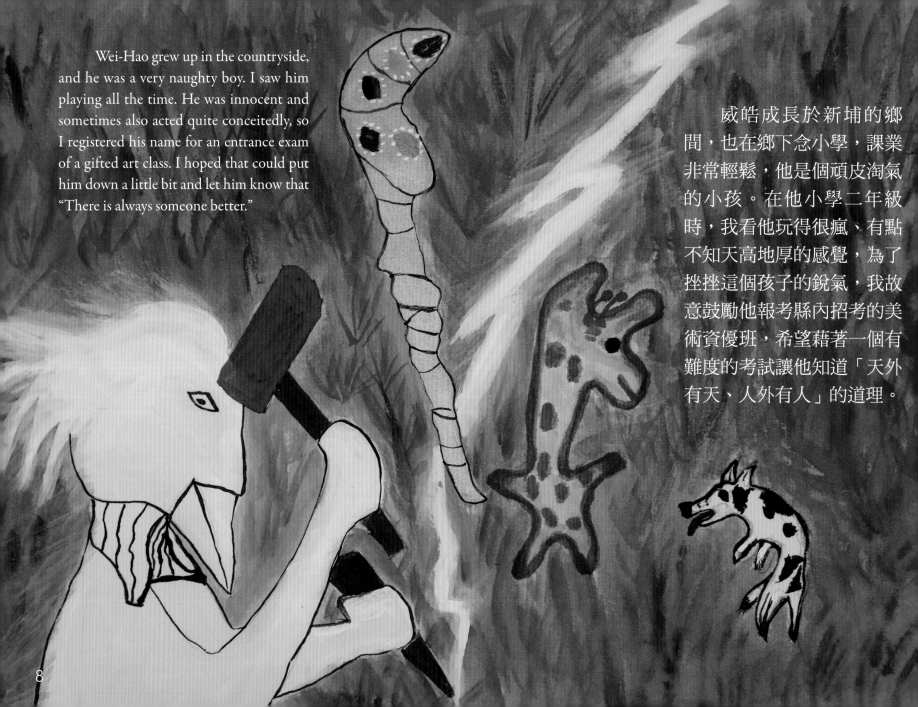

Wei-Hao grew up in the countryside, and he was a very naughty boy. I saw him playing all the time. He was innocent and sometimes also acted quite conceitedly, so I registered his name for an entrance exam of a gifted art class. I hoped that could put him down a little bit and let him know that "There is always someone better."

威皓成長於新埔的鄉間，也在鄉下念小學，課業非常輕鬆，他是個頑皮淘氣的小孩。在他小學二年級時，我看他玩得很瘋、有點不知天高地厚的感覺，為了挫挫這個孩子的銳氣，我故意鼓勵他報考縣內招考的美術資優班，希望藉著一個有難度的考試讓他知道「天外有天、人外有人」的道理。

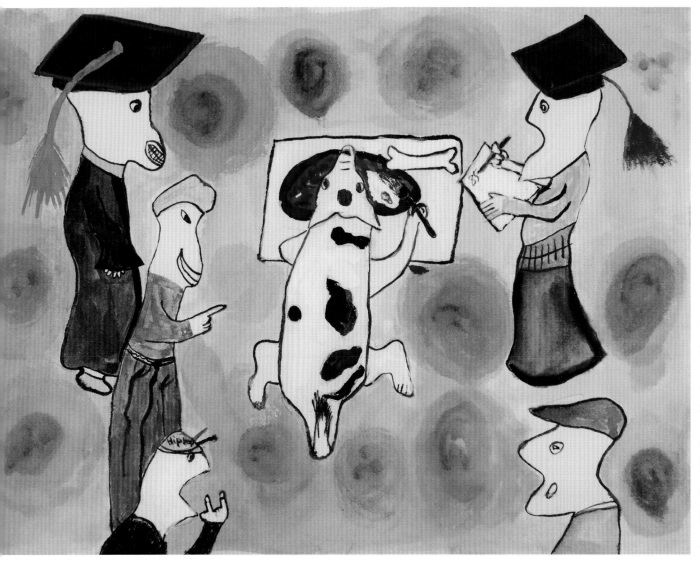

朋友知道我要讓威皓報考美術資優班，笑我搞不清楚狀況，因為一般打算考美術資優班的孩子大概在考前三年即需預做準備，美術資優班可不是說考就考的；威皓在考前一個月才決定報考，絕對準備不及！我心想，原本我的打算就只是要挫挫威皓的銳氣而已，壓根兒沒盤算過他會考上。但朋友既然這麼說，為了讓他的成績不要太難看，就為他安排上了四堂美術課，讓他至少知道如何運用顏料才上場考試，志在報名不在錄取。

A friend laughed at me, saying, "It's impossible. Most people spend three years preparing for the test." But I thought to myself, "It doesn't matter. I just want to let Wei-Hao have this experience. I don't expect him to get in." But not to make him feel embarrassed or perform too badly compared to others because he had not received any training, I let him attend four art lessons in advance to enable him to know at least a little about how to use pigment.

然而，考試結果完全出乎意料之外！在200多名報考生中，只錄取30人，威皓竟然以中上的成績被錄取了。

Unexpectedly, the result turned out to be pretty good. He got an over-average grade and was one of the thirty children admitted out of two hundred.

10

　　於是，威皓準備轉學到位於市區的學校
就讀三年級，從鄉下學校轉到都市學校，我
們心中也有些忐忑，擔心他會出亂子，再三
叮嚀威皓不能玩瘋了、要守規矩。

Thus, in the third grade, he moved into the city.
We were worried that he might make trouble, so we kept
reminding him not to do so.

三年級這一年之中威皓胖了10公斤，他喝水喝得很兇，看起來不太對勁。那年暑假，就帶威皓去做身體健康檢查，結果正常；但到了四年級，他的體重一直往上飆，喝水頻尿的問題越來越嚴重，中西醫看遍了都沒改善。四年級結束的暑假又再次帶威皓到大醫院檢查，結果還是顯示一切正常、沒問題。我心中暗自想著，或許是威皓換環境、功課壓力太大造成這些身體狀況，我便跟威皓建議，是否轉回原來的鄉下學校，沒想到一向愛玩的威皓竟然說：「讓我把這裡（新學校）的東西通通學完，我再回去。」原來威皓在新的環境已經養成了對美術的學習熱忱，於是我選擇讓他繼續留在美術班。五年級時，他的畫作得到縣美術比賽第一名，他好高興，也慶幸堅持留在美術班是正確的抉擇。

During the third grade, Wei-Hao gained ten kilograms. Every day, he drank an extremely huge amount of water. I took him to have a health check-up, and the result just showed normal. But his weight kept going up and he almost never stopped drinking water and going to the toilet. Neither western nor Chinese medicine did help. After the end of his fourth grade, I took him to a larger hospital. However, they still could not find what was going wrong. I wondered if it was the new environment and the heavier burden of the schoolwork in the city that caused too much pressure on him. So I suggested his transferring back to the school near home. But Wei-Hao didn't want to do so. He said, "Let me finish the school here in the art class before going back." In the fifth grade, he won the first prize in a natimal art contest. He was very cheerful. "Fortunately, I had stayed. The previous insistence is worth it!"

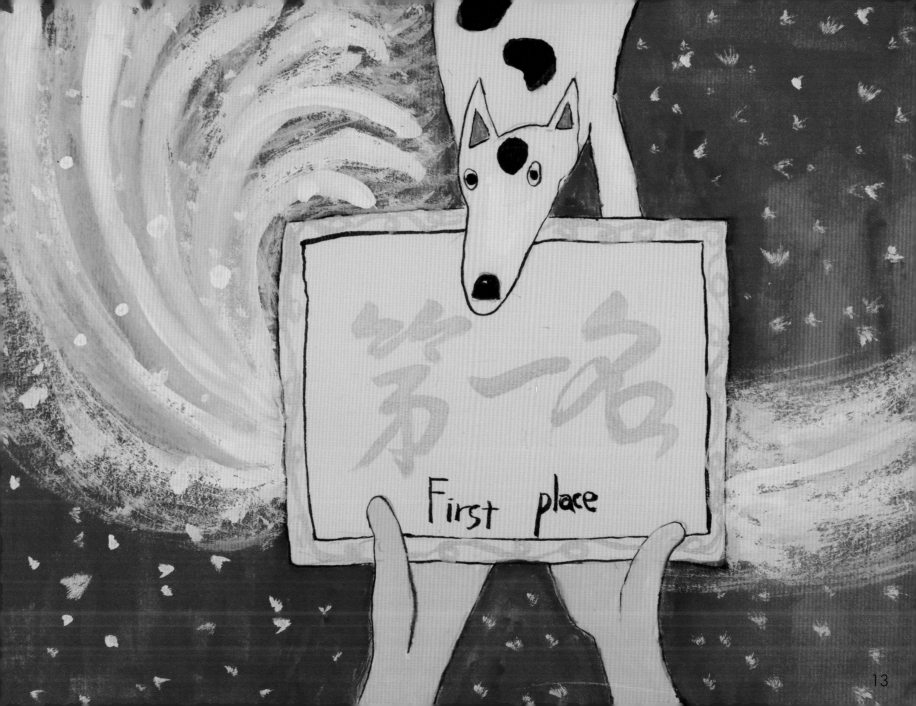

然而，威皓的身體狀況是越來越差，除了猛喝水、頻尿、體力變差外，他開始有嘔吐現象，還跟我反映他看的字會移動。六年級畢業時，再次到醫院檢查，馬上被安排緊急住院，因他腦部長瘤，而且已情況危急！

等待開刀是非常煎熬的過程，9天9夜我淚流不止，每天對著窗外雙手合十，祈求上蒼諸佛慈悲救救我兒！

But his body condition was still getting worse. Besides frequently drinking water and urination, he became very weak. He started to vomit, and the characters in books started moving in his view. After his graduation of elementary school, we went to see a doctor again. This time the doctor arranged an emergency ward immediately after the diagnosis. It was a brain tumor and the situation was very urgent.

While we were waiting for his operation, I cried nine days and nights. I prayed with hands together in front of the window, hoping that the Buddha would help him to get through it.

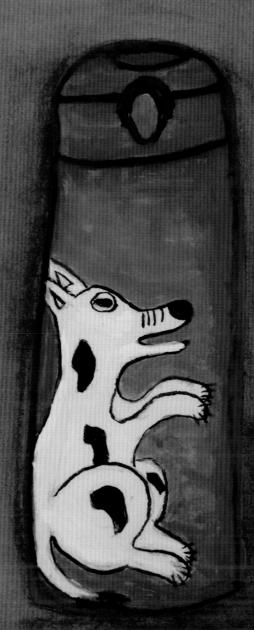

腦瘤手術後，接著化療
電療，之後威皓三寶就出現
了——水壺、尿壺、嘔吐袋
不離身，他不停地喝水、尿
尿、嘔吐、走路不穩、跌跌
撞撞，甚至雙手無法施力，
經常讓東西掉落地上。

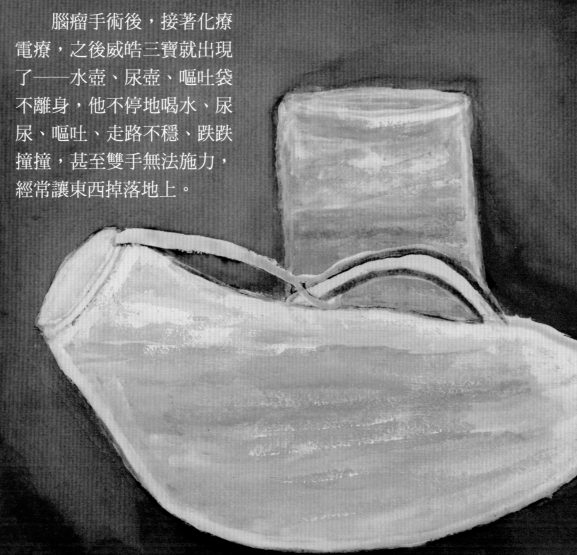

After the chemotherapy, three things were always with Wei-Hao— a water
bottle, a chamber pot and a vomit bag. He constantly drank water, went to the toilet
and vomited. He could not stand steadily and could not even hold things in hands.

在威皓住院期間，有位親戚來看望我們母子，她提議要送威皓一本書，我好奇地問她是怎麼樣的書？原來她想送一本「教威皓如何向爸、媽、朋友說再見」的書，雖然知道她是一片好意，但當時的我，聽到這樣的話，卻彷彿提早被宣告死刑般的痛苦，當下我立即婉拒了她。就在住院這段期間，另外一位陌生的志工媽媽，她的孩子也曾經住過兒童病房，她不時地會過來探視關懷，有一天，她和我分享了一些她兒子小時候生病的相片，看著她兒子生病時在病房中辛苦的樣子，我真得覺得好絕望，但翻著翻著相片簿，接著卻是她的孩子長大後帥氣健康的模樣。我們之間沒有太多的對話，但她的分享深深地鼓勵著我勇敢去面對當下的困難、並想像期盼未來可能的美好。

想想那個媽媽就是啟發我的榜樣，她在我心裡埋下一個小小的種子——希望自己有一天也能和她一樣，能給受苦的人帶來希望。藉由威皓的詩畫故事，希望能讓生病、痛苦的人能得到安慰，讓失敗、受傷的人可以受到鼓勵，讓累了的人可以得到片刻的寧靜休憩。

When Wei-Hao was in hospital, a relative of ours came to visit us and offered to give Wei-Hao a book. I was curious about what the book was about. It turned out to be a book about how Wei-Hao could bid farewell to his parents and friends. I understood that she did it with good intentions, but after hearing what she said, I felt as if I were doomed to death as a bolt from the blue. I declined her offer promptly. A few days later, a kind woman volunteer came to visit us. Her child had been in the children's ward a couple of days and thus made it a habit to visit and inquire after patients in the hospital when she was free. She let me look through her son's photograph album. The first several photos showed how her son had suffered in the ward. Seeing the pain he had suffered, I fell into despair. But then, to my surprise and delight, I saw the photos of her son as a healthy, handsome young man. There was little dialogue between us, but her sharing cheered me up and instantly inspired me to brave all my difficulties and have a vision of a rosy future.

Looking back fondly on that memorable moment, I found that loving mother had set a good example for me to follow. She had planted a seed in me and I hope this seed can come up soon and that I can bring hope to sufferers. How I wish Wei-Hao's poems and pictures as well as his story to be able to ease the anxiety, worries, and pain of those in pain, serve as an inspiration to those who are frustrated or seriously hurt either physically or mentally, and afford an opportunity for a moment of tranquility and relaxation to those who are tired out.

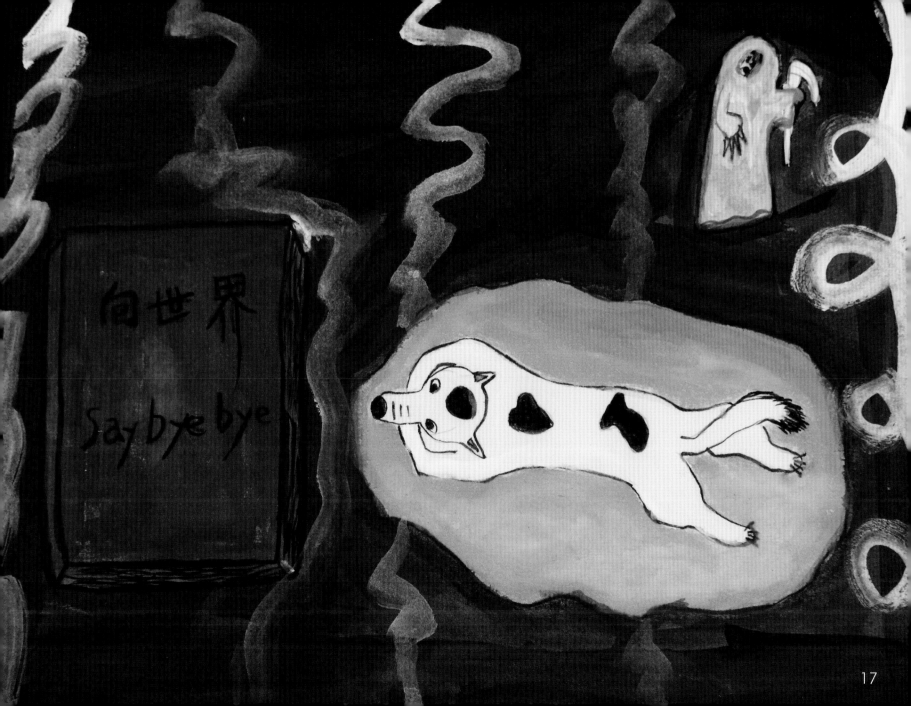

因著身體的折磨，他的情緒起伏開始變得很大，我停下工作專心陪著他。休養一年後，我陪著威皓上國中，希望能讓生活再度回到正軌，然而威皓從開學後，早上上課一直吐到中午，膽汁都吐出來了；持續了三個星期，老師終於忍不住提議我幫威皓請假。

　　雖說是在家休息，但其實威皓已足足在家一年多的時間了，我規劃著既然無法繼續讀書，或許可以送他到教養中心。沒想到問了三、四間特殊學校，回應都是「不到重殘程度無法收容」。心中的無助沮喪讓我不禁嚎啕大哭，我的心幾乎要瘋狂，內心深處的傷痛無可排解，心底吶喊怨恨老天爺的無情折磨！然而，橫擺在眼前的問題依然要面對，只好回頭尋找特殊教育鑑定，鑑定結果，威皓智商61、心智年齡7至8歲（威皓當時已14歲2個月）。

After Wei-Hao got sick, he became emotional. I quitted my job so that I could take care of him full-time myself. After one year of recuperation, Wei-Hao started junior high school with my company. From the first day, he vomited in class. It lasted for three weeks. Finally, even the teacher could not help but suggest my letting Wei-Hao have days off. Since he could not go to regular school, I thought maybe he should go to an education center for the children with special needs. I asked three or four education centers, but I got only rejection for the same reason. "We only accept children with severe disability and Wei-Hao's situation is not so bad." I was desperate. I cried, screamed and complained. But facing Wei-Hao every day, I knew I still needed to deal with it. Later I found "the evaluation for special education." They asked Wei-Hao to do an intelligence test. The result showed his intelligence quotient was 61, which indicated a mental age of 7 to 8--at that time Wei-Hao was already 14 years old.

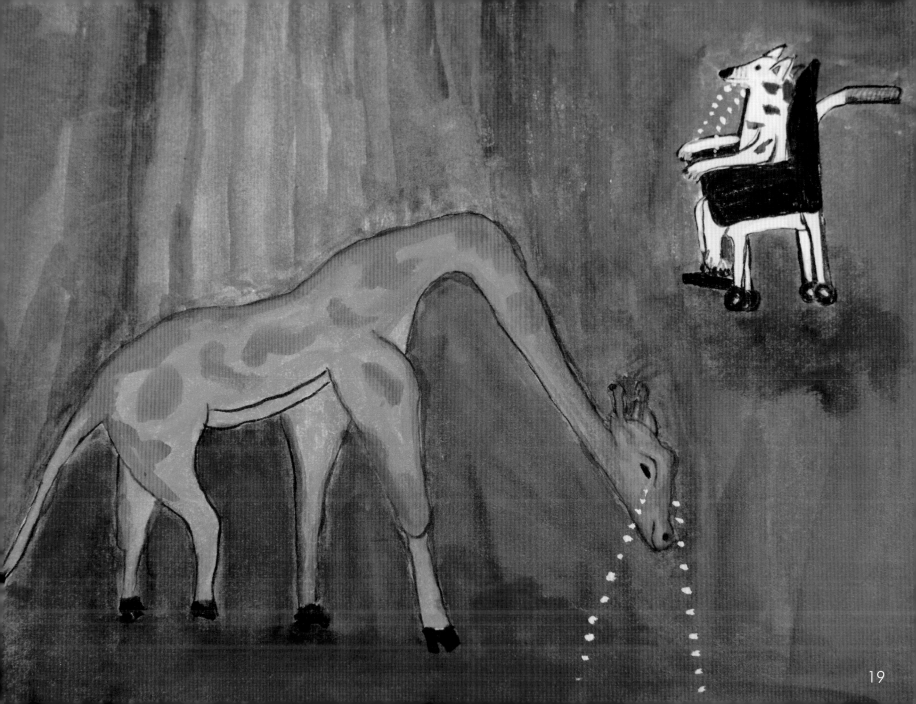

19

既然特殊學校進不去，我只好帶著威皓回到普通學校，經由心理師的輔導協助，我們採取了一些應變措施，例如，考試時將考卷放大，由我在旁邊唸題目，讓視力變差的威皓能夠作答；下課後，我會陪著威皓去上數學家教，回家再替威皓複習。曾經聰明伶俐的威皓已經退步到完全不會加減乘除；原本很會寫小詩的他，現在連國字都不會寫。我一步一步慢慢地陪他，用說故事的方式，協助他把每個字的部首拼起來。好不容易到了國二，尋尋覓覓下終於找到一所適合威皓就讀的學校——也是全國唯一特殊生、普通生融合的學校，學校採小班制教學、也沒有課業壓力，威皓慢慢地適應下來，終於順利地完成國中學業。

　　Wei-Hao started to go to school again. But his sight got very bad. Only with the instructions of a counselor, the magnified test sheet, and me aside reading out the questions, Wei-Hao was able to take the test.

　　After school, Wei-Hao had still a math tutorial. I sat aside and also listened so that I could help him to review the material later again. He was once very smart, but now he could not even do the simplest arithmetic. He used to write poems, but now he couldn't even write a Chinese character. I made up stories to help him to remember the strokes of characters.

　　In his second year of junior high, we found a more suitable school for him. This is the only school in Taiwan that special students and normal students are in the same class. Theirs are all small classes without so much stress for students. Wei-Hao got used to it gradually and completed his junior high there.

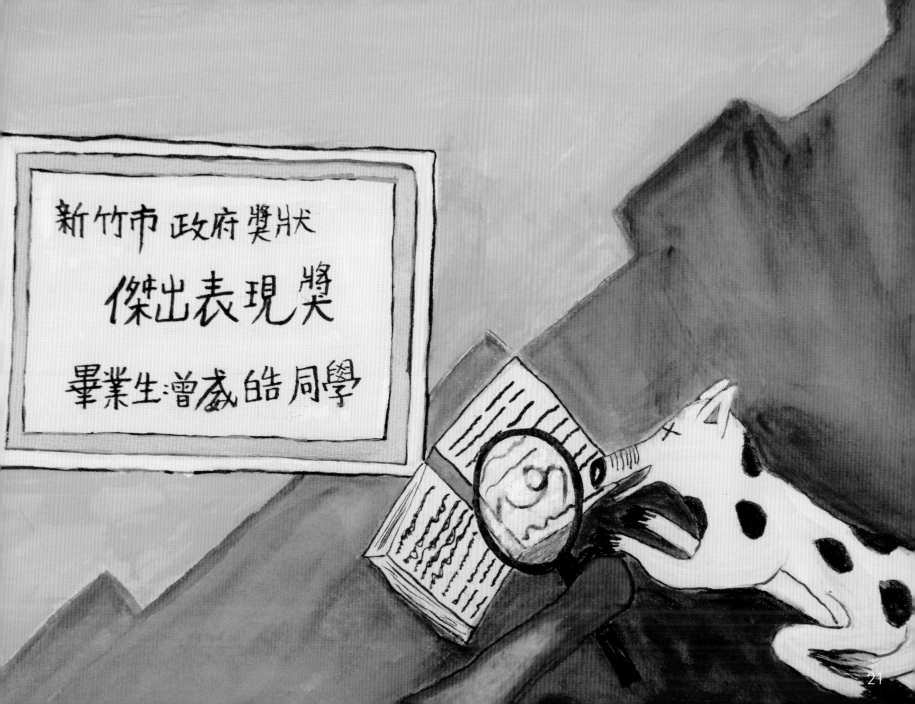

升學高中，我們為威皓選了一所私立的天主教學校，威皓狀況特殊，我想有宗教背景的學校應該有較好的校園氛圍，可以包容威皓這樣的學生。威皓讀多媒體設計科，每天的作業都必須畫素描、描摹許多細小的線條，這對威皓來說相當痛苦，因為他的手不穩、無法像以前那樣靈活地用筆，他的作品猶如幼稚園小朋友畫的圖。讀完一年級的某一天，系主任私底下找威皓，希望威皓二年級轉系，我得知後請教班導，仁慈的班導認為威皓自小熟悉的是畫圖，其他科系對威皓壓力會更大，班導提議繼續留在多媒體設計科。

　　After his graduation from junior high, we chose a private Catholic high school for him. We hoped the religious school could provide a friendlier and more tolerant environment for Wei-Hao's special condition. Wei-Hao chose multi-media design to study. Every day he needed to sketch a lot. Drawing lines was especially painful to him, because he could not hold a pen firmly and thus he could not move a pen at will. Hence, his works were all like the drawings by kindergarten kids. One day in the second year, the head professor of the department asked Wei-Hao if he wanted to transfer to another major. After learning that, I visited Wei-Hao's mentor. The mentor was kind and understood that drawing was what Wei-Hao had been familiar with since he was a kid and that the other majors might put more stress on him. The mentor suggested that we should just follow what we had planned.

23

我只好親自面對系主任，在電話中聽她責怪威皓的不是，她嫌威皓功課差、電腦繪圖課不認真、甚麼都學不會；還說威皓樣樣跟不上同學，會被同學排擠。（所幸班導把學生教得很好，同學們都對威皓很包容。）我連連賠不是，為造成主任困擾道歉，並向主任保證請家教指導威皓電腦。當然也私下詢問威皓問題出在哪兒？原來威皓因為聽不懂主任的電腦課，所以才不認真；我也為此特別找有特教經驗的電腦老師幫威皓補習，總算威皓在惡補下達到了學校要求的畢業門檻（丙級證照），全家欣喜若狂！

　　I called the head professor. She complained almost one hour about Wei-Hao's bad grade, poor works and lack of attention in class. "If he continues like this, he will be isolated in his class," the professor said. Fortunately, the mentor and the classmates were all tolerant. Wei-Hao got along with them. At that time I could only keep apologizing. And I promised that I would find a tutor to teach Wei-Hao to use the computer. I asked Wei-Hao why the professor said that he never paid attention. He said that was because he could not understand what the professor taught. Afterwards we really found a computer teacher with the experience of special education. Eventually, Wei-Hao still met the graduation requirement--a C-class license of drawing. The whole family was happy for him.

威皓高三時，有天有位老師問威皓，畢業後你打算要做什麼？威皓答在家開畫畫的工作室。老師不禁笑他說：「你畫成這樣你敢開工作室呀?」威皓天真自信地回答：「老師，人活著就有希望！」老師也為威皓的樂觀動容。

　　身為他的母親，我知道，威皓的樂觀就是他歷經數次生死關頭能活下來的最大動力！就如剛開完刀清醒時，他對我講的第一句話：「難關難過關關過！」

Another day, a teacher asked Wei-Hao what he wanted to do in the future. Wei-Hao answered that he wanted to open a painting studio. The teacher joked, "You draw like this. And you want to open a studio?" Wei-Hao answered, "As long as I live, everything is possible." The teacher considered Wei-Hao to be very optimistic.

From the viewpoint of his mother, the clearest view, his optimism drives him to go through every moment between life and death. As he put it when he just came to himself after the operation, "There are many huge or small obstacles on the way. I am overcoming all of them."

威皓高中畢業的半年前，我擔憂威皓的未來，請教靈學大師黃老師指點迷津，真的很感謝黃老師，在她的鼓勵下，威皓開始認真地畫圖寫詩，國小4年級寫的詩，迄今已隔了10年，經過重新整理，威皓的第一首新詩於105年1月8日誕生了！寫詩畫圖半年後，威皓開始練書法，這是以前從來不敢想像的，不穩的手竟然可以拿起毛筆寫字了！謝謝書法老師謝珮珍的教導及國畫大師謝秀英的鼓勵，感謝吳芸嫻老師在百忙中幫威皓寫簡介故事，還有謝謝許以臻小姐的英譯，更感激陳鳴弦老師為我們審閱校對英文稿。

　　感謝所有幫助我們的親朋好友們！感恩上蒼諸佛的慈悲！感恩這一切的因緣俱足！無上的感恩！

　　Six months before Wei-Hao's graduation, because I worried about his future, I consulted Mrs. Huang, a master of zen. I am really thankful to Mrs. Huang as well as Bodhidharma that Wei-Hao started to create paintings and poems after the psychic's encouragement. Wei-Hao's first poem was composed in his fourth grade in elementary school-- already ten years ago. Half a year later, he started to learn calligraphy. It is what we could not expect before that he can move the calligraphy brush so well with his feeble hands. I appreciate the instruction of Wei-Hao's calligraphy teacher, Ms. Pei-Chen Hsieh and the encouragement of the master of traditional ink painting, Ms. Hsiu-Ying Hsieh. Moreover, I have to thank Professor Yun-Hsien Wu for writing the introduction to Wei-Hao's work, Ms. Yi-Chen Hsu for the English translation and Mr. Matthew Chen for his careful proofreading.

　　I would like to thank all our friends for their help and the Buddha for the blessing and everything we met and have!

29

美麗心世界
A Real Brave New World

威皓作品欣賞
Paintings by Wei-Hao Tseng

圖／詩／書法：曾威皓　Painting/ Poetry/Calligraphy: Wei-Hao Tseng
簡介故事：吳芸嫻　Introduction: Yun-Hsien Wu

雖然這些詩畫不是最美的，但威皓克服不穩的手，用盡全力了！

Though these pieces may not be the most beautiful or perfect,
Wei-Hao has tried all his best to overcome his unstable hands while painting!

小河

小河是個膽小鬼
雨只要打他一下
他就一直跑
晴天時
卻又神氣地慢慢走
雖然魚蝦愛和他玩躲貓貓
他卻一點也不生氣
可惜現在很多人蹧蹋他

2006

Little River

Little river is a coward;
Just one tap of raindrop can make him run away.
But on sunny days,
He takes an easy airy pace.
Although fish and shrimps like to play hide-and-seek with him,
He is not angry at all.
What a pity many people are defiling him.

2006

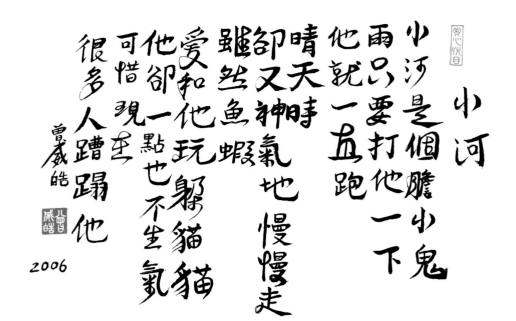

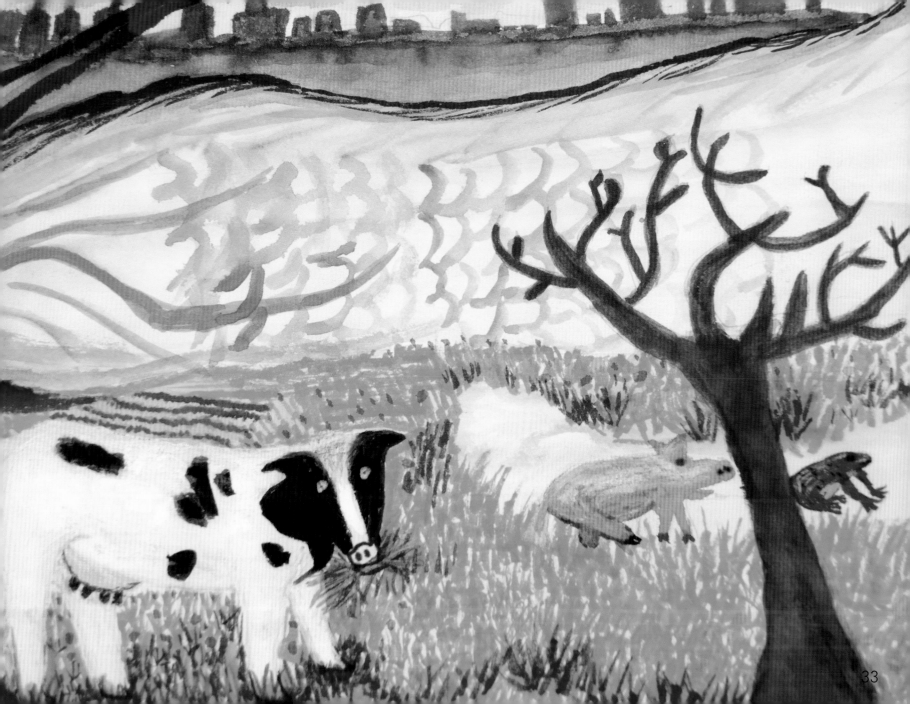

小河

　　小小的河匯流到大海，一朵一朵的波浪沒入海裡就不見了，小波浪擔心著自己的消逝，這時一個聲音出現了──「你就是大海、大海就是你；當你流進大海，小小波浪就成了大海的一部分，你並沒有消失，你只是變得更大了。」在威皓的小河裡，我們看到小河波光粼粼，好似一條龍、又好似宇宙裡無盡的迴旋，乾淨的小河給大地帶來生機，牛、豬、青蛙都可以在乾淨的小河邊玩耍，但小河另一頭林立的工廠，是小河潛在的威脅，工廠裡漫流出來的黑霧像幽靈一樣，籠罩在生機盎然的草地，若我們不保持儆醒，那枯死的樹豈非人類的未來？

註記：小河的詩寫於威皓國小四年級十歲生病前。在十二歲生病之後，歷經了八年復健，威皓在二十歲時才重拾畫筆。嘗試了兩次構圖失敗，第三次威皓終於畫出他心中的小河，於是第一張畫誕生了！

Little River

The little river is heading toward the sea. In the estuary, the small waves would be swallowed by the larger waves, so the little river is worried that it would disappear. At this time, a voice comes out, "You are the sea, and the sea is you; when you join the sea, then every small flow of yours would be part of the sea. You would not disappear, but only become more extensive."

In this painting of Wei-Hao's, we can see the little river glinting in the sun. It seems like a dragon, or also like an endless swirl in the universe.

The clean little river brings life to the earth, so the cow, the pig and the frog can play on one side of it. However, the other side is full of factories, which are the potential threat to the little river. Plumes of black smoke billowed from the factory chimneys look like ghosts. They cover the sky above the lively meadow.

Doesn't the dying tree foreshadow the future of human beings?

Notes: Wei-Hao has written the poem, *Little River*, at ten before he got ill. After eight years of rehabilitation, Wei-Hao finally picked up his paintbrush again at twenty. With two-time drafting, Wei-Hao eventually completed his first work after a long while.

自由翱翔

我想要自由
像小鳥一樣自由飛翔
可以看看山
也可看看海
可惜我不是會飛的鳥
還是要再學習才能飛翔
當會飛翔時還要反哺

2016.2.11

Fly freely

I want to be free,
To see the mountain,
And to see the sea.
But I'm a bird who cannot fly.
I still need to learn before I can fly.
After I know how to fly, I will bring food back to my parents. [1]

1 Ravens are reputed to feed their parents after becoming adults.

自由翱翔

我想要自由
像小鳥一樣自由飛翔
可以看看山
也可看看海
可惜我不是會飛的鳥
還是要再學習
才能飛翔
当會飛翔时
还要反哺

曾威皓

2016.2.11

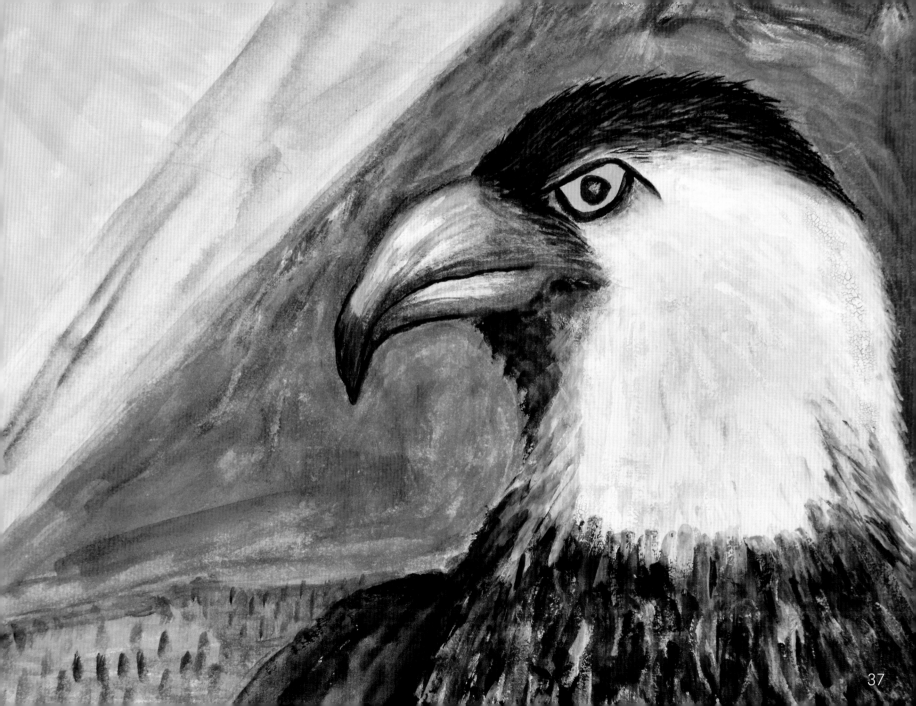

自由翱翔

　　國小畢業的那一年，威皓因猛灌水、又出現嘔吐現象，被送到醫院做全身檢查。沒想到在這次的檢查中，醫生發現威皓腦部長瘤、而且情況危急，當天威皓立即就被安排了住院，在措手不及的情況下，小小的威皓馬上接受了腦部手術，並住院18天。在這18天中，威皓被羈束在病床上，身體虛弱讓他完全失去行動的自由。

　　「自由翱翔」這幅圖是描述威皓當時的心境，威皓渴望自己能像老鷹一樣自由地翱翔在天際，無拘無束、遠眺世間百態。

　　接受腦部手術後的威皓，其實已不復之前在課業學習上的聰明伶俐，面對閱讀、理解、及記憶上的困難，其實威皓備感挫折、也飽受折磨。因為生病讓威皓身體虛弱、體力不好；然而正因為生活這樣的羈束，反而開啟了威皓在色彩的世界中自由揮灑豐富想像力的空間。

　　老鷹在天上多麼意氣昂揚，小小威皓心裡有個大大的志向，期盼有朝一日自己也能像老鷹翱翔天際、鳥瞰天下，一無所懼。

Fly Freely

In the year of Wei-Hao's elementary school graduation, Wei-Hao was sent to hospital because of his consumption of an unordinary amount of water and frequent vomiting. Unexpectedly, he was diagnosed with a brain tumor. On the same day, he was asked to stay in the hospital. Without any preparation, Wei-Hao, at such a young age, received brain surgery and remained in hospital for eighteen days. In the eighteen days, he was constrained to the bed and lost the freedom to move about.

The painting *Fly Freely* depicts Wei-Hao's desire for freedom. He hoped that he could soar like the eagle in the sky and overlook the earthly world down coolly.

After the brain surgery, Wei-Hao was not so clever as before and had difficulty in reading, comprehension and memorizing, which frustrated him a lot. Moreover, due to the sickness, he was weak and didn't have so much energy. On the one hand, Wei-Hao's body was under great constraints. On the other hand, unfreedom brings up the enormous imagination inside his head.

The eagles fly in high and vigorous spirits. Wei-Hao had an ambition that he could fly like the eagle in the sky someday and overlook the world without any fear.

落葉

落葉時木呻
別君於千里
落葉化成泥
回歸木已了
春時葉重生
死而又再生
生死輪迴中

2017.11.2

Shedding Leaves

The trees groan when they are shedding their leaves.
It's time to say goodbye.
The leaves fall and become part of the soil,
And then part of the trees.
The leaves will come back in the next spring.
They die and rise from the dead.
Life and death are nothing more than reincarnation.

落葉時木呻
別君於千里
落葉化成泥
回歸木已了
春時葉重生
死而又再生
生死輪迴中

曾威皓

2016.2.11

40

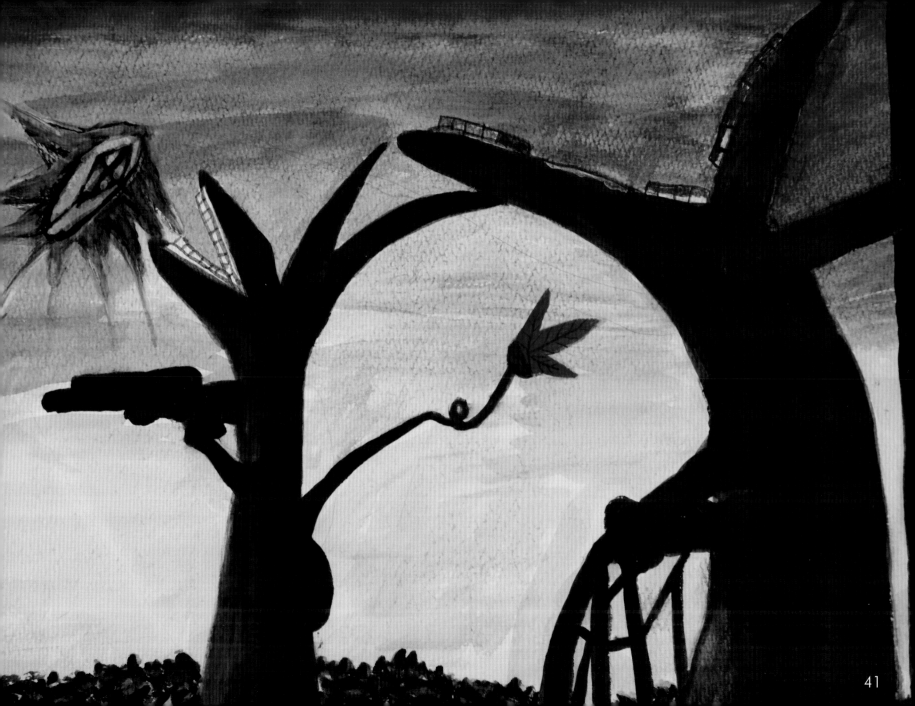

41

落葉

　　秋風吹過，老樹吟哦，落葉滿地。

　　在落葉這一幅圖中，有一棵齒牙零落的老樹、還有一口整齊貝齒的新樹，老樹的樹根看起來就像現代老人家常拿著的助行器，老樹已經垂垂老矣，在葉子落下來的時候，老樹發出的嘆息聲也顯得那麼地幽微；隨著歲月的累積，曾經意氣風發的一片蓬勃綠景，將要凋零回到大地，乾枯腐朽的落葉會成為新生命最重要的養份，等到春天再來，生機再現，新的生命、幼苗，同樣必須再次對天災的磨難、與人為的破壞，並在其中掙出一片生機，長出新葉、傳承生命。在這一幅圖當中，我們看到所有生命在平凡中的不平凡。

Shedding Leaves

After the autumnal breezes sweep by, the trees groan while shedding leaves all over the ground.

In the painting *Shedding Leaves*, an old tree, which has lost almost all its teeth, stands next to a young tree, which has nicely aligned teeth. The roots of the old tree look like a walking aid for the elderly. The aged tree groans when its leaves are falling down. Even its groan is so weak. As years go by, what used to be lush now withers and will soon return to earth as nutrients. When the spring comes, the vitality will come back again along with the new sprouts. The new life also needs to face natural tests and the destruction by human beings, strives for its own space, grows green leaves, and spreads the seeds to perpetuate life. In this painting, we can find the unordinary in the ordinary of life.

化履

化履塵步行
步入天之行
履壞心不壞
化解心怨也
即步入天界

曾威皓 2017.7.6

Shoes

The shoes walk through the journey of life,
The journey to heaven.
The shoes will wear out, but souls would never wither.
Forgive others and yourself,
And then the soul can go back to heaven.

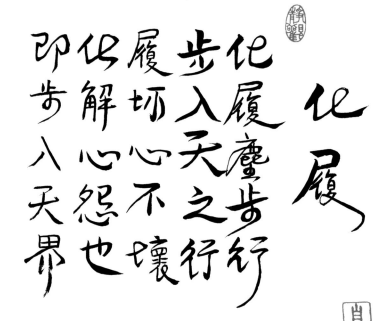

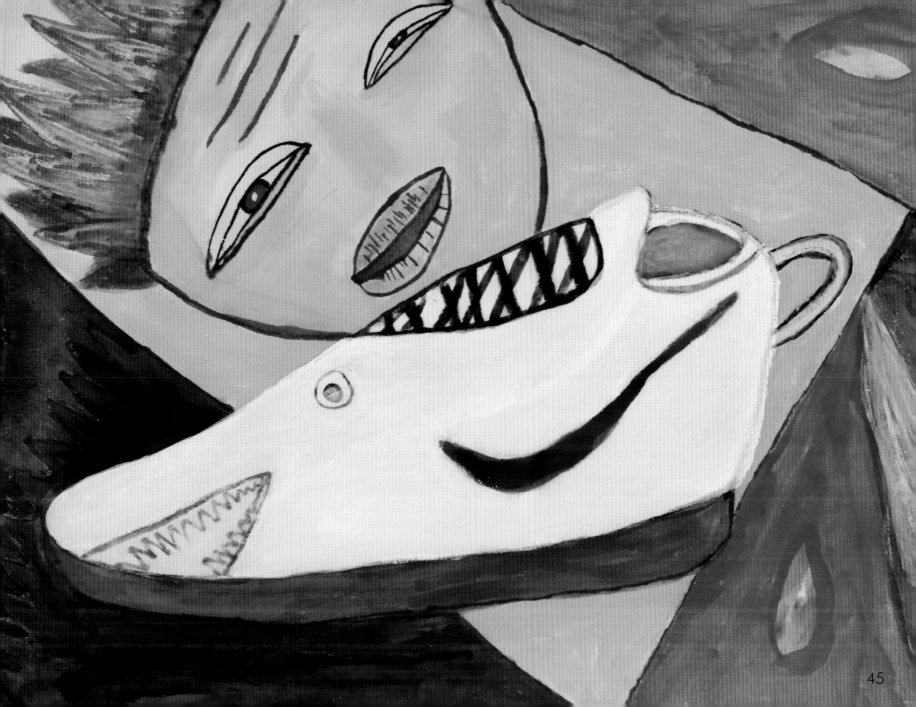

45

化履

　　人的身體是否就像一雙鞋？我們的靈魂按著上天的安排來走這塵世一遭。這一輩子的時光，當我們善用這肉身行善，即能緩步向著天界邁進；在這過程中，或許這雙鞋是要飽受折磨的，一方面老、病、死的威脅如影隨形；另一方面，人生旅途每每還是會踩到許多坑洞石頭、甚至道旁荊棘割壞我們的鞋。

　　在人生的道路上痛苦與挫折是難免的，但要不要調整我們的心態來避免受苦卻是在於個人的抉擇。「一念天堂、一念地獄」，世間中所發生的事，其實沒有好壞，如果能一直保持善念，相信每件事的發生自有道理，把每次的煩惱都當成學習進步的機會，那麼縱然磨穿了這雙人生鞋，只要莫忘我們來到世界的初衷——即是善用暇滿人身修行精進，那麼縱使隨著歲月流逝，肉身損害，鞋已磨破，不堪再穿，都能覺此生無憾。

　　畫中的婆婆是從小帶大威皓的祖母，總是一遍又一遍地重複著述說她過往的故事，隨著婆婆慢慢地邁向失智，漸漸地一些過去的事，阿婆也不再說了、也想不起來了～威皓心中不禁思索，阿婆！您走過這麼多路，可曾記得您磨穿多少鞋？

Shoes

Is the human body just like a pair of shoes? Our souls come to the worldly life with the assignment of destiny. When we make good use of our bodies to do good, we move forward to heaven. In the process, the shoes might suffer from different hardships. First of all, the threats of senescence, illness and death are always with us like our shadows; in the second place, many pits and stones along the way or thorns on the trail might wear the shoes.

On the journey of life, pain and frustration are unavoidable. However, it's our choice if we adjust how we think to stop torturing ourselves. "The mind is always in place, and in itself can make heaven Hell, and hell Heaven." All that happens in the world is neither good nor bad. If we always hold good thoughts, believe that everything that happens has its own reason, and consider each worry we have to be an opportunity to learn and to grow, then even if our bodies and shoes are worn out and years have passed, we will feel no regrets.

In the painting is Wei-Hao's grandmother. She used to repeat her stories again and again. She has senile dementia and has become forgetful. Wei-Hao asked in mind, "Granny has walked through almost the whole journey of life. But can she still remember how many shoes she has worn out?"

面具

我是一個帥氣的面具
我也是個醜陋的面具
我是一個滑稽的面具
我也是個恐怖的面具
我是一個善變的面具
無人了解我心的面具

2017.6.25

Mask

I am an attractive mask.

I am an ugly mask.

I am a ridiculous mask.

I am also a frightening mask.

I am a variable mask.

No one understands the heart behind the mask.

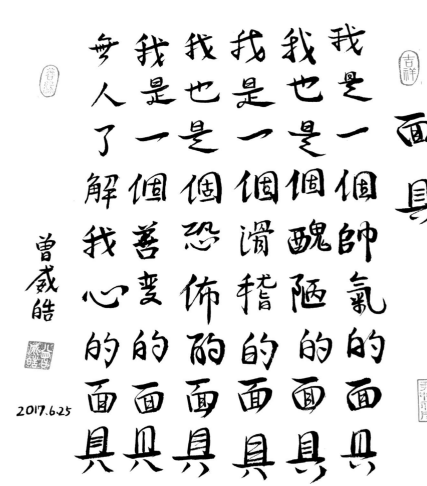

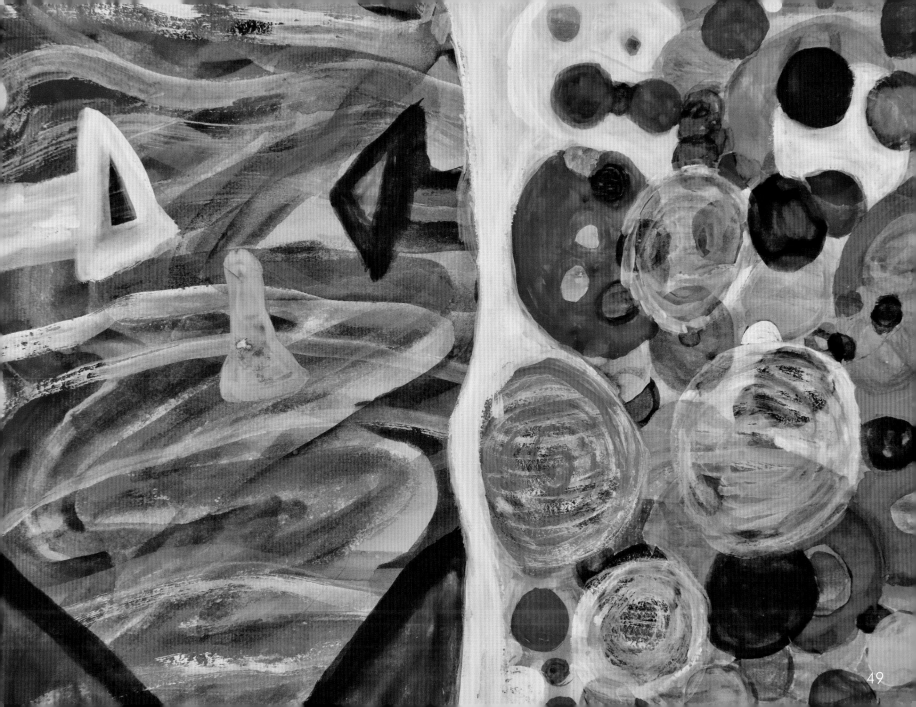

49

面具

　　大概有不少人都不諱言地承認自己是「外貌協會」會員，看到長相好的人會先入為主地認為，這麼漂亮的人應該是個溫柔的人吧？長得帥的人應該能力很好、或至少不會騙人。然而事實真的如此嗎？外表跟人的內心真的都會一致嗎？

　　長輩總是叮嚀我們「人不可貌相」、「不要以貌取人」，然而曾幾何時「以貌取人」竟不再被視為膚淺！我們的社會現在瘋狂地迷上整形，因為根據某些新聞報導說，一張漂亮的臉蛋是進入這個社會最重要的貴賓卡。然而漂亮臉蛋、迷人外型下真正的內心世界是怎麼樣的，誰人知道呢？

　　面具這幅圖想訴說的是，世間上的人往往帶著面具在生活。除了化妝想要變出一張社會覺得賞心悅目的臉外，就算是在精神層面，所有的人也是在扮演一個符合社會期待的樣子與角色，我們想讓別人看到的「我」，跟真正的自己其實不盡相同。在當今社會文化中常常聽到鼓勵我們「做自己」的聲音，然而又有多少人可以完全無畏社會眼光、表現全然的自己？怯弱的人嘗試想要表現勇敢，孤獨的人企圖偽裝開朗，沒有安全感的人更想處處強悍；在外表的美好堅強下，每個人的心底深處都潛藏著一口看不透、也猜不透的井。

Mask

Many people today might admit without embarrassment that they are lookists. They assume that pretty women are gentle and handsome men have probably greater ability, or at least are honest. But is it true? Can one's outer appearance reflect the inner side?

Our elders always tell us appearances can be deceptive and warn us not to judge a book by its cover. Since when has judging a person only by his look not been considered shallow? People are crazy about cosmetic surgery because a beautiful face is like a VIP card in our society. Who cares the inner side under the beautiful face and figure?

The painting *Mask* shows that people in the world often wear masks. Besides putting on make-up to have an appealing face, many people also try hard to play a role who can meet the expectations of their society. What we try to show others is often different from what we really are. Today we are often encouraged to be ourselves. However, how many of us can totally ignore others' judgment. Timid people pretend to be brave; lonely people pretend to be outgoing; insecure people pretend to be strong. Under the strong and wonderful appearance, everyone hides his vulnerability deep in mind.

花草

何故於乎生
無故於枯死
進化輪迴道
轉而成為花
轉而成為果
一生了卻已

2017.6.28

Flora

How come a life comes to the world,
Only to wither for no reason?
Ending in every reincarnation.
It turns into a flower,
Turns into fruit,
And ends up with the fulfilment of the meaning of the life.

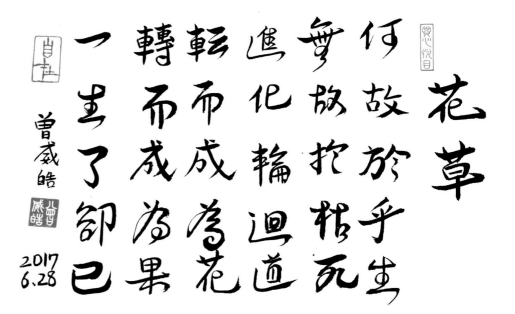

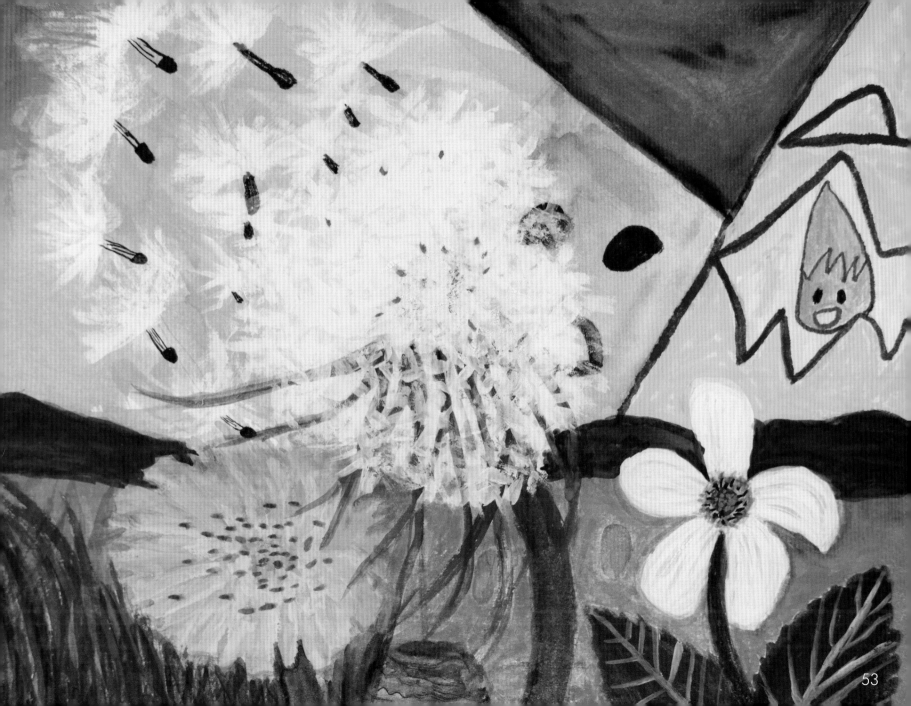

花草

　　有一天早上威皓跟媽媽在田邊散步，就在柏油路旁有一棵大樹，大樹不知已豎立在路旁多久的時間了，但馬路的修復工程，讓滾燙的柏油披蓋住它植地的根，為了一口乾淨的空氣，樹根用著它強韌的生命力撐破了柏油路，拔柏油路而出，而樹根之間的糾結形成了一個小小的洞，在這柏油的洞縫裡沒有土、也沒有水，但一些不知名的小花小草卻在這個柏油洞當中生存了下來，展現了神奇的生機。回家之後，威皓畫下了他心有所感的這一幕。柏油洞中的花草是不知名的花草，但在威皓的圖中，他畫下了自己最喜歡的小花蒲公英，蒲公英很輕，隨風飄散，對威皓而言，它代表著無盡的夢想，隨著際遇漂泊在空中，尋找落腳的地方。另外威皓也很喜歡鬼針草堅韌的生命力，鬼針草總是不放棄任何它可以抓住的機會。

　　大自然是我們最好的老師和朋友。媽媽和威皓一方面讚嘆，這小小的花草在這麼窘迫困難的環境當中都能占有一方天地；另外一方面更是真心希望每個生命都能自在地綻放，得以擁有開花結果的機會。威皓內心深處小小的心願可能也須賴我們所有人類能夠活得更謙卑、更尊重生命，才能達成吧！

　　在這一幅畫中有四個人，讀者們，你們要不要找找看，你看得出來這四個人嗎？

Flora

One morning, Wei-Hao and his mother were taking a walk alongside a field. Right next to the asphalt road stood a big tree, which has been there since a long time ago. However, the construction of the road covered the root of the tree with the boiling hot asphalt. To breathe fresh air, the root has struggled out of the road with its vitality. It has tangled up and formed a small hole. There is no soil nor water in the hole, but some small grass and flowers have grown there, showing the miracle of life. After getting back home, Wei-Hao painted this scene, which had lingered in his mind. Actually, Wei-Hao didn't know what plant they were. He painted his favorite plant the dandelion. A dandelion is light and wafts up the wind. For Wei-Hao, it represents an endless dream, which travels following fortune until it finds a place where it belongs. Moreover, Wei-Hao also likes the vitality of beggar-ticks because they never let go any chance they can grab.

Nature is our best teacher and friend. On the one hand, Wei-Hao and his mother admired the fact that the small flower can also grow in a barren place. On the other hand, they sincerely hope that every life can live freely and have the chance to blossom and to fruit. The wish might be achieved only when all of us become humbler and respect all the lives more.

In the painting, there are four people. Dear readers, can you find all of them?

執著

無限之日
有限之期
人始於塵
無人道醒
必須內醒
何須執著

2017.5.15

Stubbornness

Infinite days,
but a finite date.
We begin our life in the earthly world.
No one awakens us,
So we need to wake up our inner minds by ourselves.
Why need to be stubborn and persist in error?

May 15, 2017

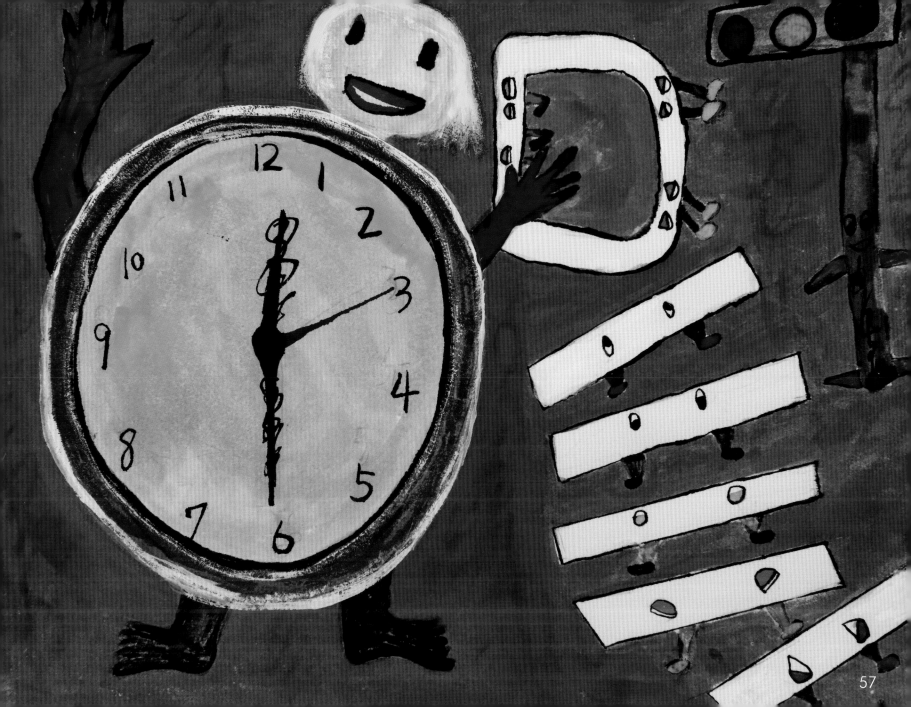

執著

　　某一日，媽媽為了一件事糾結於心，苦惱了兩個禮拜。威皓看到媽媽煩惱的樣子，提筆寫下這首詩。

　　詩中的寓意其實非常簡單。人出生於滾滾紅塵當中，每個人都有許多的困難在考驗著我們，很多問題無人能給我們答案；我們無法從別人的話、別人的境界中去得到醒覺，只有深刻地自我反省，或許我們能慢慢地學習放下執著。

　　來自外境的考驗總是層出不窮，每天人所面對各式各樣煩惱總是可以剛好塞滿一整天。若我們願意停下腳步、平心靜氣去想想，為何煩惱，煩惱的根源是什麼？難道我們真的找不到解脫煩惱的方法嗎？

　　在我們的身邊，甚麼最執著？威皓認為是規範著時間的時鐘，時鐘總是分秒不差的報時；甚至不同的國家都透過時差，規範所有國家人民都擁有同樣的一天廿四小時。時鐘公平又準確，提醒我們四時變化、及一日何時當作何事的時間紀律。如此看來，執著未必是壞事，因為執著讓社會有了一些共通根本的規範與觀念，但在嚴守紀律下，我們也須知道，太陽不是因報時而升起；所有規範只為貼近真理，卻從來都不曾是真理。若能知道時鐘的侷限，就能明瞭，我們實在無須執著，放下我們自以為是的真理，找到生活的彈性，當能讓我們的生活更加悠然自在。

Stubbornness

Wei-Hao's mother had been wrestling with one question for two weeks. After seeing his mother so worried, Wei-Hao wrote down this poem.

The poem implies that we are all born into the mortal life. Everyone needs to go through many difficulties. There are many questions no one will give us the answer to, or cases we cannot learn from others. Only through a deep reflection on ourselves can we really let go of the unnecessary stubbornness.

Tests never stop confronting us. All kinds of worries occupy our minds. If we're willing to stop for a while and think why these worries come, couldn't we find a solution?

What is the most stubborn thing in our daily life? Wei-Hao thinks it's a clock, which regulates time. A clock always reports time precisely. A clock is fair and accurate. Even though we live in different time zones, we all own 24 hours a day. A clock reminds us of time and schedules. In this way, stubbornness is not necessarily bad. Because of its stubbornness, we have common rules and principles in the world. But we also need to know that the sun rises not because it follows the rule of time. All the rules are created to approximate the truth, but they are never the truth. Though the clock can show time, it cannot show the day and night. There is a limitation in the clock. Likewise, we should not adhere to the rules that we consider to be truth. Then we can find the flexibility in life and live more freely.

爸爸

爸爸像一顆蘋果　　我們就是裡面的種子
希望我們長成蘋果樹　　對我們寄予厚望

爸爸像顆地球　　養育著許多人
儘管我們踩著您　　但您也無所謂
我們非常感恩您

爸爸像位長官　　有時嚴厲有時溫柔
但心裡還是愛著我們　　我愛您爸爸

<div align="right">2016.6.30</div>

Father

Daddy is like an apple, and we are the seeds inside.
You have pinned all your hopes on us, expecting each of us to grow into an apple tree.

Daddy is like the earth, nourishing so many people.
Although we stand over you, you don't mind it at all.
We are really thankful to you.

Daddy is like an official, sometimes strict and sometimes gentle.
You love us deep in your heart.
I love you too, Daddy.

<div align="right">June 30, 2016</div>

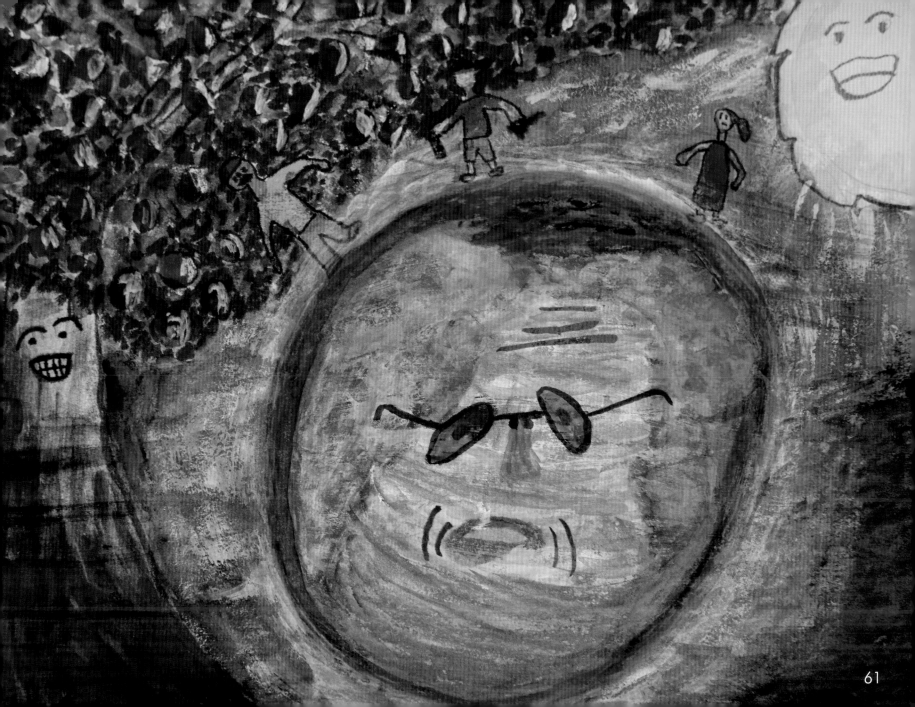

爸爸

　　爸爸像地球一樣，支撐著我們擁有的一切；爸爸的愛像大地，即使我們感覺不到，卻都活在他暖暖的胸懷之中。

　　威皓的爸爸就像傳統家庭的父親一樣，支撐著整個家的家計。在威皓的眼中，爸爸總是眉頭深鎖、永遠在擔心著甚麼。威皓不是一般的小孩，或許這點也帶給爸爸很大的壓力，看到威皓，爸爸總是要求著他該做些什麼；對威皓而言，爸爸總是在責罵他，嘴角邊深深的法令紋，代表著爸爸的權威與期待。

　　孩子眼中的爸爸是兇惡的，孩子知道爸爸每開口可能又是責罵，看到爸爸總是躲得遠遠的。但孩子完全不懂爸爸的心嗎？應該也未必。

　　威皓圖中的爸爸有兩個形象，一個是身負重任的地球，滿臉愁容，擔心著未來。但在圖的另一側，飽滿的蘋果樹上結實纍纍，蘋果樹笑得樂開懷，或許這才是爸爸真正的內心世界，期盼子女成材，都能展現不同風華，看著子女得以豐收結果，這或許就是爸爸衷心至盼！

Father

A father is like the earth that supports all we have. Father's love is like the land —we all live in the warmth of his embrace, even though we don't notice.

Wei-Hao's father is like every other traditional father, who supports all the household needs. From Wei-Hao's view, his father always frowns, as if worried. The deep folds next to the father's mouth represent the father's authority and expectations.

Wei-Hao is not a normal kid, which also brings much stress to his father. His father is strict and requires a lot of Wei-Hao. Sometimes the words from the father sound like scolding to Wei-Hao, so he would hide himself up.

So the kid doesn't understand the father's love, does he? Not necessarily.

In Wei-Hao's painting, the father has two images. On one side of Wei-Hao's painting, the earth looks worried under the burden of responsibility. On the other side, a fruitful tree laughs delightedly. Maybe that is the real mind in the father. He expects kids to succeed and show their own peculiar talent, and then sees the children's effort paying off—these are all his heartfelt wishes.

自討苦吃

自討苦吃何哀哉
今生莫懸錢多少
離世帶不走一分
莫嫌世道太奇怪
為錢忙碌為錢苦
自討苦吃化成甘

2016.1.18

Bringing Trouble on One's Own Head

How sad to see people bring trouble on their own heads!
Don't let money occupy your mind.
No one can take any penny away in the end anyway.
Don't complain that our world is too ridiculous:
Busy for money and suffering for money.
Being in trouble but still feeling content.

January 18, 2016

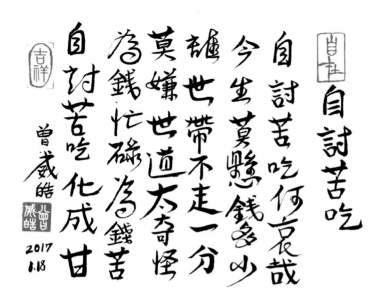

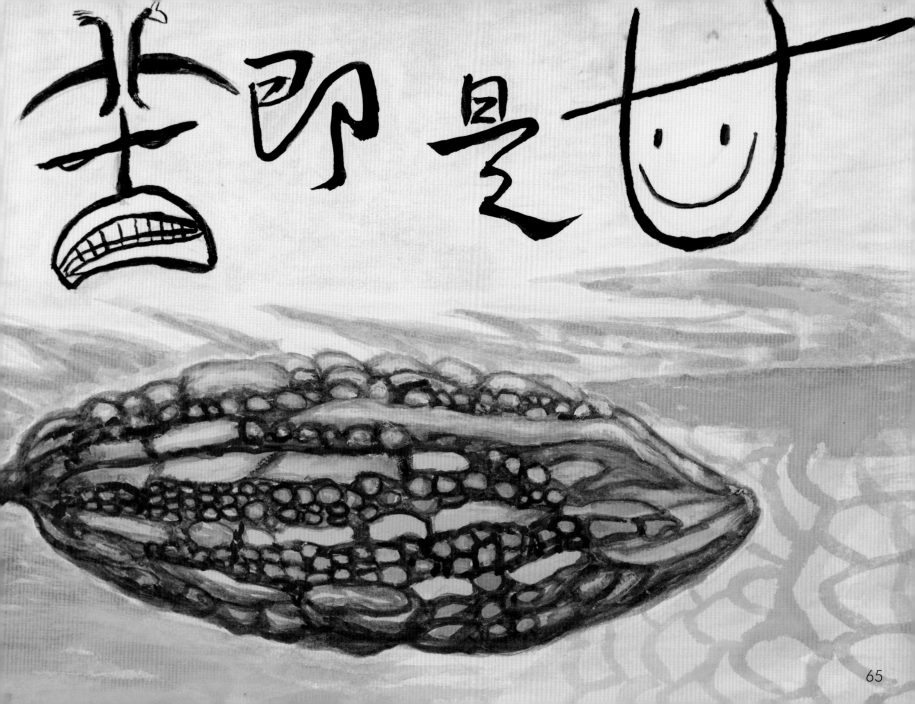

自討苦吃

我們常說：「人生苦海。」然而，眾苦從何而來呢？

人的一生，能吃多少、用多少，其實冥冥之中自有定數。個人勞動的出發點原本只為求三餐溫飽，最後卻經常落入俗世生活，利益名聲物慾的追求中打滾，不得翻身。有句俗諺：「人為財死、鳥為食亡。」也很貼切地道盡眾生為求生存生計的一個根本的煩惱。

當人們有了某種能力，並在社會上找到適合的舞台，從而充分發揮自己的才華與潛能時，他會得到相當的金錢上的酬賞。金錢的交易幫助社會充分地分工與互助。因此，獲取金錢最大的意義，是我們找到運用自己能力來回饋社會的方式。

但許多人忘了，金錢的累積代表著自己對社會奉獻的能力，回饋造福社會才是獲取金錢背後更重要的意義與價值；若賺錢只為了銀行存摺上數字的增加，賺錢只為賺更多的錢，那麼這樣子單純地為財富積累而奔忙工作其實已忘了賺錢的初衷，無異於「自討苦吃」。

年少的威皓，其實已看透很多大人看不到的盲點。「賺錢」跟吃苦瓜一樣，是件很營養的事；因為經濟的困頓與壓力，激發出個人奉獻社會的能力，因此，金錢的分配其實目的在肯定個人能力對社會的付出。

苦瓜的背景是紅龍，紅龍代表一種尊貴的成就，這樣的成就，絕非僅是物質的積累，更是人性最尊貴處的展現。「吃得苦中苦，方為人上人。」懂得吃苦、享受吃苦，能體會愛因斯坦所說：「我們的一生脆弱而短暫，唯有奉獻社會，才能找到生命的意義。」這樣的人生真諦的人，終能在人生苦海的磨練中，成就自己，不枉此生。

Bringing Trouble on One's Own Head

We all say that life is tough, but where do the tough days come from?

In our life, it might already be determined how much we can eat and how much we can consume. The original reason for work is for survival, but people often follow the desire and fall into the chase after fortune and fame. The old saying "Birds die for food, and people die for fortune" is the best portrayal of modern life.

When one has certain capability and finds a suitable stage to exercise one's talent, then one can gain the corresponding reward. The trade of money helps the division and the cooperation of work in our society. Thus, the most important meaning of earning money is that we contribute or repay to the society in our own way.

But many people forget that the accumulation of money represents the ability that we can contribute, and that the contribution to the society is the very value why we go to work. But if we earn money only to see the growing amount in our accounts, or earn money only to earn more money, then it already violates the original object of human endeavor, and no matter how busy we are, it is not worth it. "Nothing truly valuable arises from ambition or from a mere sense of duty; it stems rather from love and devotion toward men and toward objective things," Einstein said.

Though Wei-Hao is young, he can already see the people's blind spot. Earning money is nutritious as well as eating bitter melon. Because of the financial pressure or feeling not enough, people can truly achieve their potential.

The red dragon which lies behind the bitter melon in the background represents honorable achievement. This achievement is certainly not the accumulation of material wealth but an exhibition of noble and pure character. "No cross, no crown." Understanding why the difficulties can help us improve and how to enjoy the process of overcoming difficulties, we can keep going on the way of fulfilling ourselves.

神仙

李白乃是詩仙
威皓乃是神仙
李白喝酒作詩
威皓喝水作詩
李白氣度瀟灑
威皓自覺不凡

2016.11.16

Fairy

Li Bai is a fairy poet.
I am fairy Wei-Hao.
Li Bai drinks wine while writing poems;
Wei-Hao drinks water while writing poems.
Li Bai is free and emancipated;
Wei-Hao believes himself extraordinary.

November 16, 2016

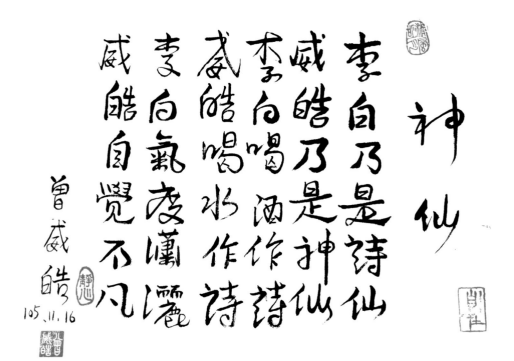

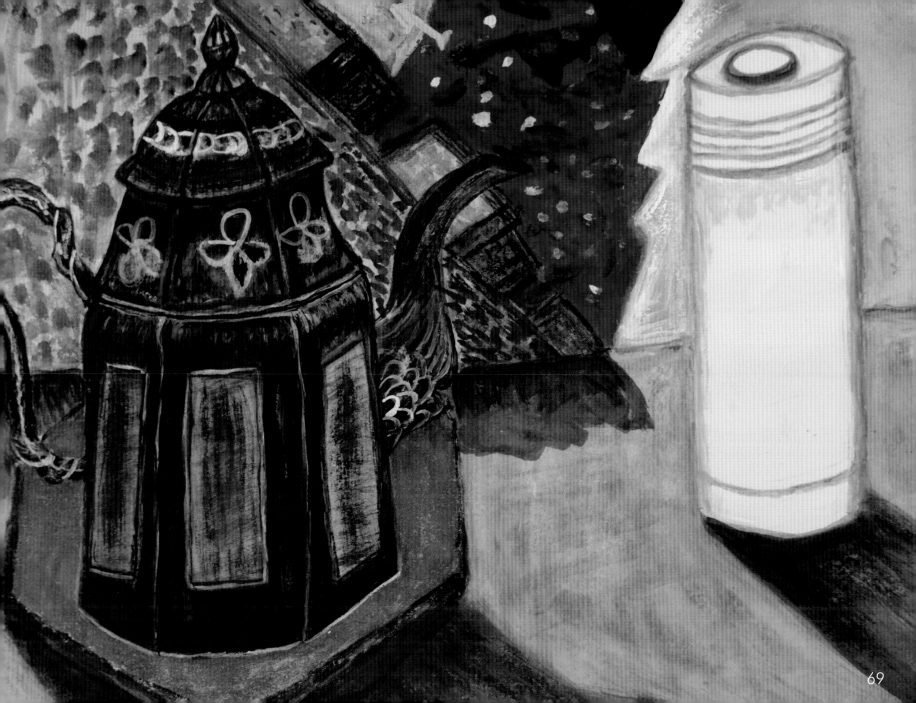

神仙

　　威皓非常喜歡李白的詩，李白喝酒作詩，生活中離不開酒壺，威皓的生活中則絕對不能沒有水壺。威皓作詩全憑一時靈感，就像李白作詩也大部分在半醉半醒之間。其實，人生本就是一齣戲，上了舞台，每個人在自己的角色各自精采。威皓的年紀不大，但遭遇的挫折不少，特殊的境遇成就自命不凡的威皓。

　　威皓甚為喜歡李白〈月下獨酌〉一詩：

　　花間一壺酒，獨酌無相親。舉杯邀明月，對影成三人。
　　月既不解飲，影徒隨我身。暫伴月將影，行樂須及春。
　　我歌月徘徊，我舞影零亂。醒時同交歡，醉後各分散。
　　永結無情遊，相期邈雲漢。

　　詩仙李白雖然擁有盛名，但在這首詩中映照出詩人心中依然孤寂；又或許在這世界中無人不孤寂吧！每個人都渴望能找到知音，但世界上真的能心靈投契的人是多麼的少？在畫裡李白的酒壺，正對著威皓的水壺，在不同的時光背景（古代的長城面對現代的臉孔），兩人深夜星空中對談，心靈上的投契超越時空的限制惺惺相惜。

　　若論這世間，我們唯一忠實的跟隨者只有我們的影子吧！人在尋覓知音的時候，是否也期盼一個能配合自己步調的人？但誰願意為照護他人、放棄自己，以別人的節奏來踩著自己的人生步伐呢？那皎潔的明月、那永遠守護我們生存的土地或許是我們在這世間最亙遠的依靠。然而，人壽有限，即使明月長照，我們終將依然孤寂地揮揮衣袖走上歸途。

Fairy

Wei-Hao likes to read Li Bai's poems. Li Bai wrote poetry while drinking wine. A wine pot was indispensable in Li Bai's life, while for Wei-Hao is a water pot. Wei-Hao's poems are all created in a spontaneous inspiration. Likewise, most of Li Bai's works came out in a state between consciousness and tipsiness. Actually, life itself should be like a drama. On the stage, everyone performs themselves in their own roles. Wei-Hao has experienced a lot of frustration at such a young age. The special and adverse circumstances make Wei-Hao believe he has a special destiny.

The following is one of Wei-Hao's favorite poems by Li Bai.

DRINKING ALONE BENEATH THE MOON -- by LI BAI (701-762)

O lonesome bottle of fine wine among the flowers --
I have no dear one to drink with (at these wee hours) !
I raise my cup to the Moon for her to join me --
With the Moon, my Shadow, and I : We're people three.
But O ! She cannot drink, my poor little full Moon !
Quite mindless, too, my Shadow just mimics my move.
I'll keep Moon and Shadow company, though, for now;
We shall enjoy ourselves -- for it's Spring, this is how.
I sing songs for attentive Moon (and have my fill);
I dance and my Shadow, though confused, follows still.
While sober, let's make merry, be joyful at heart --
For after I am drunk, we three will have to part.
With Platonic love fore'er, long tours we'll devise --
Let's meet again far'way where the Milky Way lies ! [2]

2 Translated by Frank C Yue; http://chinesepoetryinenglishverse.blogspot.de/2013/03/beneath-moondrinking-alone-li-bai-o.html

Though the fairy poet Li Bai had a great reputation, we can see the loneliness in his work. Or no one is not lonely in this world. Everyone is longing to find a true friend who understands him. But how few are the people who might match us? Li Bai's wine pot in the painting is next to Wei-Hao's water pot. In the different time and space, the two people converse with each other under the stars. The meeting of understanding minds are beyond the limit of time and space.

Maybe the only loyal follower in the world is our shadow. When people are searching for a true friend, maybe they expect a person who can adjust their pace to their speed. But who is willing to sacrifice himself to take care of others? Who is willing to let others' steps tread on his life? The bright moon and the land that protect us might be the only permanent support. However, the lifespan is short. Even though the moon shines forever, we will end up departing this life alone.

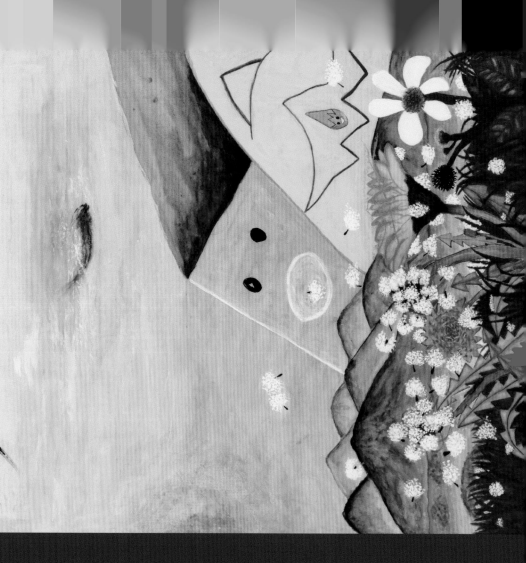

執著Stubbornness · 書法Calligraphy · 140x35cm

創造生命的奇蹟：詩人畫家曾威皓

圖／詩／書法　曾威皓

簡介故事　吳芸嫻

翻　　譯　許以臻

插　　畫　曾威皓

攝　　影　黃柏翰

專案主編　陳逸儒

出版編印　吳適意、林榮威、林孟侃、陳逸儒、黃麗穎

設計創意　張禮南、何佳諠

經銷推廣　李莉吟、莊博亞、劉育姍、李如玉

經紀企劃　張輝潭、洪怡欣、徐錦淳、黃姿虹

營運管理　林金郎、曾千熏

發 行 人　張輝潭

出版發行　白象文化事業有限公司

　　　　　412台中市大里區科技路1號8樓之2（台中軟體園區）

　　　　　出版專線：（04）2496-5995　　傳真：（04）2496-9901

　　　　　401台中市東區和平街228巷44號（經銷部）

　　　　　購書專線：（04）2220-8589　　傳真：（04）2220-8505

印　　刷　基盛印刷工場

初版一刷　2019年11月

定　　價　250元

國家圖書館出版品預行編目資料

創造生命的奇蹟：詩人畫家曾威皓／曾威皓圖、
詩、畫；吳芸嫻簡介故事. --初版.--臺中市：白
象文化，2019.11
　面；　公分
中英對照
ISBN 978-986-358-873-3（平裝）

1.水彩畫 2.書法 3.作品集

948.4　　　　　　　　　　　　108012931

白象文化　印書小舖 PressStore 出版新紀元　出版 · 經銷 · 宣傳 · 設計

www.ElephantWhite.com.tw　f 自費出版的領導者　購書 白象文化生活館